Tate Olszewski Book Store: Art Book.

Tate Olszewski Book Store: Art Book.

Tate Olszewski Book Store: Art Book.

Tate Olszewski Book Store: Art Book.

Tate Olszewski Book Store: Art Book.

Tate Olszewski Book Store: Art Book.

Tate Olszewski Book Store: Art Book.

Tate Olszewski Book Store: Art Book.

Tate Olszewski Book Store: Art Book.

Tate Olszewski Book Store: Art Book.

Tate Olszewski Book Store: Art Book.

Tate Olszewski Book Store: Art Book.

Tate Olszewski Book Store: Art Book.

Tate Olszewski Book Store: Art Book.

Tate Olszewski Book Store: Art Book.

Tate Olszewski Book Store: Art Book.

Tate Olszewski Book Store: Art Book.

Tate Olszewski Book Store: Art Book.

Tate Olszewski Book Store: Art Book.

Tate Olszewski Book Store: Art Book.

Tate Olszewski Book Store: Art Book.

Tate Olszewski Book Store: Art Book.

Tate Olszewski Book Store: Art Book.

Tate Olszewski Book Store: Art Book.

Tate Olszewski Book Store: Art Book.

Tate Olszewski Book Store: Art Book.

Tate Olszewski Book Store: Art Book.

Tate Olszewski Book Store: Art Book.

Tate Olszewski Book Store: Art Book.

Tate Olszewski Book Store: Art Book.

Tate Olszewski Book Store: Art Book.